A FATAL ATTRACTION

Art and the Media

The Renaissance Society at the University of Chicago

May 2—June 12, 1982

Acknowledgments

This publication was produced in conjunction with the exhibition *Art and the Media* held at The Renaissance Society at The University of Chicago, from May 2 through June 12, 1982.

We are grateful to Thomas Lawson for writing a critical essay and for advising us in many aspects of the exhibition, video and film program which it accompanies; to Buzz Spector, artist and member of the Society's Board of Directors, for designing the catalogue; to Alex Wald and associates of Word City, Chicago Print Center, for their typesetting and production expertise; to John Vinci, architect and friend, for his assistance with the installation; to Len Klekner, Assistant Director of the Society, and Lorraine Zoe Peltz, gallery assistant, for their work with many phases of the planning, installation, and catalogue production; to Glen Sheffer for his assistance with the video and film program; and to Catherine Becker, Wendell Ishii, Brian Kiniry, and Tom Terrell for their generous and enthusiastic volunteer work.

We would like to acknowledge the valuable assistance received from Mary Boone Gallery, Leo Castelli Gallery, Janelle Reiring and Helene Weiner of Metro Pictures, Annina Nosei Gallery, Tony Shaffrazi Gallery, all of New York City, and Young Hoffman Gallery of Chicago.

Above all we are grateful to the artists and to the lenders for their generosity, and to our Board of Directors, Advisory Board, members and friends for their continued encouragement.

This exhibition, video and film program, and the accompanying catalogue have been supported in part by grants from the National Endowment for the Arts in Washington D.C., a Federal agency, and the Illinois Arts Council, a State agency.

Susanne Ghez
Director

ISBN 0-941548-02-3

A Fatal Attraction

Since the mid-Seventies a number of younger artists in New York have been producing work which is concerned above all with the use of pictures. This work contains figures and images, but is not figurative in the traditional sense. There is no attempt to portray the look of the natural world, but rather to analyze the ways in which our understanding of that world is conditioned by the mass media which represents it to us. This work is conditioned by an understanding that the insistent penetration of the mass media into every facet of our daily lives has made the possibility of authentic experience difficult, if not impossible. Our daily encounters with one another, and with nature, our gestures, our speech are so thoroughly impregnated with a rhetoric absorbed through the airwaves that we can have no certain claim to the originality of any one of our actions. Every cigarette, every drink, every love affair echoes down a never-ending passageway of references—to advertisements, to television shows, to movies—to the point where we no longer know if we mimic or are mimicked. We flicker around the flame of our desire, loving the comfort of repeating a well-worn language and its well-worn sentiments, fearful of losing all control to that language and the society it represents. We are trapped firmly within the terms of a fatal attraction, unable to say "no" with any conviction.

The artists here admit the impossibility of negation, but attempt it anyway, through subterfuge, by turning the means of the media on themselves. By the standards of modernist formalism the resultant work is impure, a ceaseless cross-referencing of different means of representation (drawing, painting, photography, film, performance, video) and of different styles of representation (dispassionate reportage, editorializing graphics, obsessive detailing, expressionist line and/or paint, anonymous sign, commercial art of all sorts)—a spectacle of media as such. A spectacle which mirrors the spectacle of the dominant, mass media; but which returns an empty reflection.

The heart of the argument for this sort of work is to be found in an eccentric mixture of structuralism and the critical theory of the Frankfurt School, with an element borrowed from Brecht by way of Walter Benjamin. Variations of this synthesis have formed the basis of most debate within the New Left, at least in Europe, since 1968, and have been present in artistic discourse throughout the Seventies, particularly in what is loosely called Conceptual Art (most notably in the work of Michael Asher, Daniel Buren, and Dan Graham). In the practice of these artists the desire to negate the increasingly totalized alienation of a technological society has manifested itself as a concentration on the conflict between the trend towards art as entertainment and decoration, and that

which asserts that art can and should operate as a critique of subjectivity, particularly as that subjectivity is created by the production and consumption of imagery in the culture. As a result the more significant Conceptualists have found themselves pointing at the institutions which give art its meaning, and which consequently control that meaning—the museums, the galleries, the magazines.

There is a great deal to be said for this activity of pointing, yet the level of complicity involved in this theoretical radicalism must be noted, since that complicity, over time, serves to deracinate the political threat. Work of this sort simply cannot exist without the institutions whose legitimacy it seeks to undermine, and no matter how self aware, how self critical the artist, the work is steadily naturalized, declining from a strong critical intervention to little more than a cosy witticism. The radical gesture is appropriated by the culture, transformed from critique to support, reduced to a pleasing aesthetic speculation. Because of its placement in the museum the gesture is subsumed, and quickly becomes codified as masterwork; its representation, the documentary photograph, an icon of its time. The "dematerialized" art practice paradoxically finds itself reified, celebrated, and placed at a safe distance.

The newer work (as exhibited here) acknowledges this, makes of this difficulty its starting point. It acknowledges its constrained position within the culture and attempts, through a meditation on the tools of representation and appropriation, to analyze the conditions of that constraint. Working from a deeply pessimistic premise, this is an extremely self-conscious art which attempts to deny its own inevitable negation by the culture at large by pre-empting the strategies of that culture. Convinced that neither protestation nor silence offer a solution to the dilemma of co-option faced by the contemporary artist these artists resort to what Kierkegaard, in an analagous situation, described as a dialectical reduplication, a consciously deceptive ambiguity used to prevent misunderstanding and overhasty understanding. This kind of mystification used for a serious purpose does not yield an easy explanation for the less serious. The elasticity of the dialectical reduplicaton is too great for such persons to grasp, for it refutes its own explanation just at that moment of clarification when it appears set to accept an easy ideological reading, turning once again to uncertainty and doubt. An uncertainty which is the most forceful negation we can presently articulate with conviction.

The basic procedure of this dialectical reduplication is startling in its simplicity, being nothing more than a negation of the larger culture's appropriation of artistic practice through a process of re-appropriation. The theft of imagery, styles and means, the collapse of information under an emotive overload, add up to an outright denial of the rational ideals of freedom and authenticity which the bureaucratic/corporate manipulators have succeeded in subverting into irrational slogans of an ever more invisible and complete repression. It is an admittedly tricky operation, and one which inevitably confuses the liberal fellow travelers, the social democratic reformers who see a humanistic monopoly capitalism shimmering on the uncertain horizon of the future. The reformers consider this work "retro chic", dangerously close to the authoritarianism we all know we should abhor. In a sense they are correct, but their own position, a well-meaning optimism rooted in a refusal to understand the increasing depth of our subjugation to a transparent, ever-present ideology, is utterly hopeless. Indeed it is their willingness to participate in the marginalia of a safely sanitized "political art" that is the mark of a truly abject acquiescence, a silent affirmation of the status quo.

The work under consideration certainly seems to be about something, it comes on so strong in the urgency of its imagery. But such appearances are deceptive, a complex of smokescreens, a baffle to prevent easy interpretation. The pictures have been filled to overflowing, a torrent of contradictory meanings which leave the art itself a sign of meaninglessness. It is an allegorical art, but an allegory without conventional subject, an allegory about the illusion of subject under present conditions.

The artists here seek to establish a negative control over their destinies by displaying the hollow insides of the representations which trap us and deny us our privacy. The central problem for these artists is that of establishing authority without resorting to or succumbing to authoritarianism. The issues at stake revolve around the artists' need to address the constraints imposed by both the culture at large and by the appointed guardians of that culture. There is a need to address the systems of control, the nerve centers of authority, the representations of power. The discourse initiated here is the discourse of the media, mass and elite—a diffuse practice seeking its own autonomous authority through the deconstruction of the authoritarian repression inherent in the forms of representation which describe our culture.

Thomas Lawson

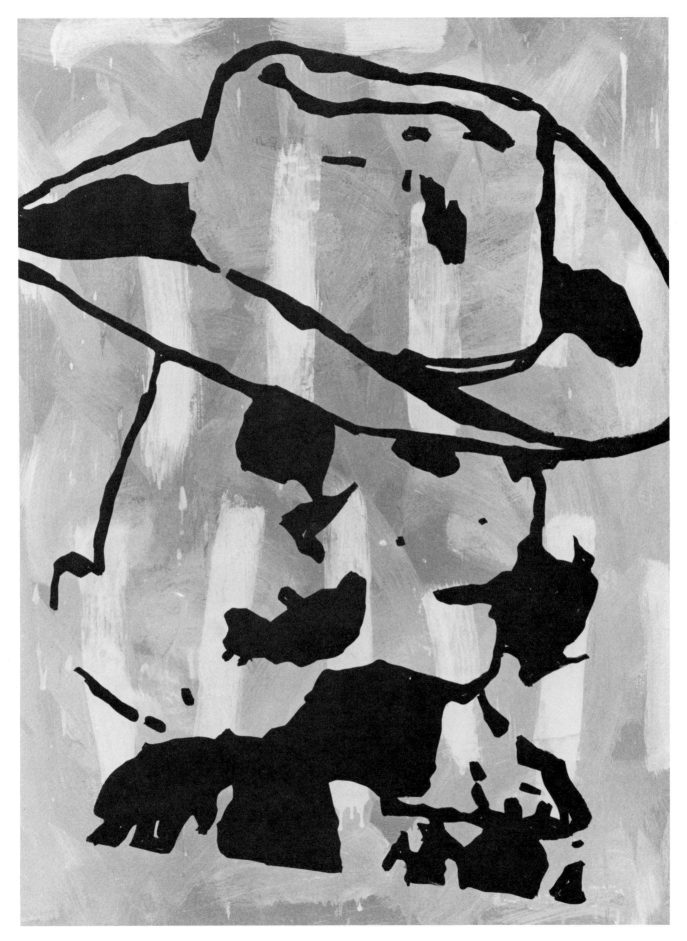

Donald Baechler, *Don's Dilemma I*, 1982, enamel on paper, 46" X 35"

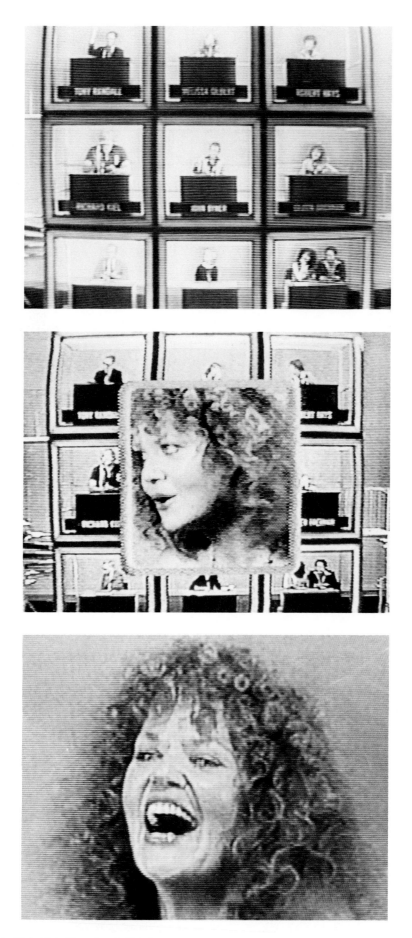

Dara Birnbaum, *Kiss the Girls: Make Them Cry,* © 1979, ¾", color,
stereo sound, NTSC , 7 mins., stills from the videotape

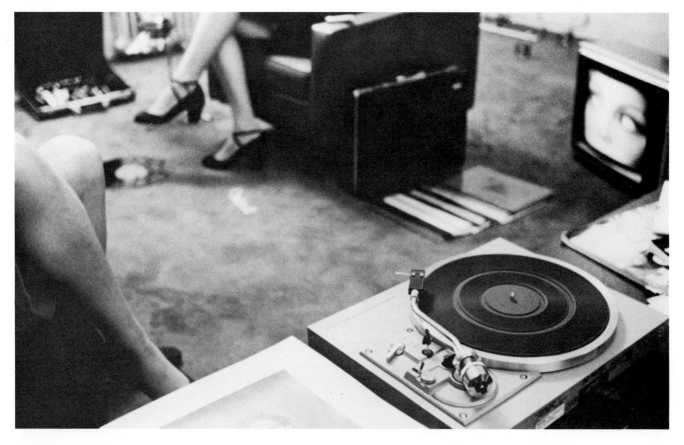

Barbara Bloom, *The Diamond Lane,* 1981, 35mm, color, still from the film

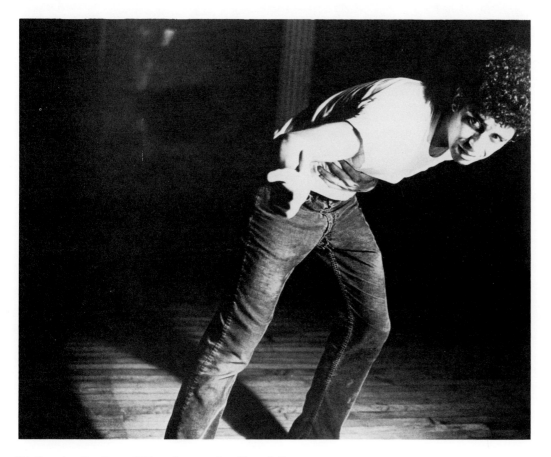

Eric Bogosian, *Fun House,* 1981, performance shot. Photo: Jo Bonney

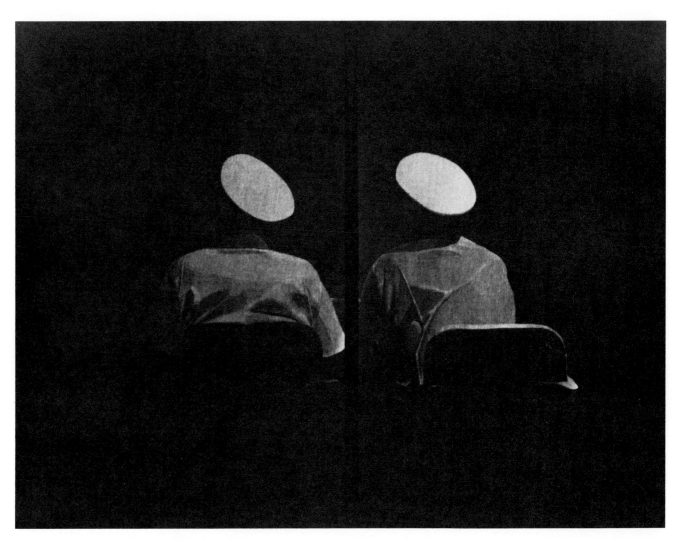

Troy Brauntuch, *Untitled,* 1981, pencil on paper, 46" X 63½".
Photo: Pelka/Noble

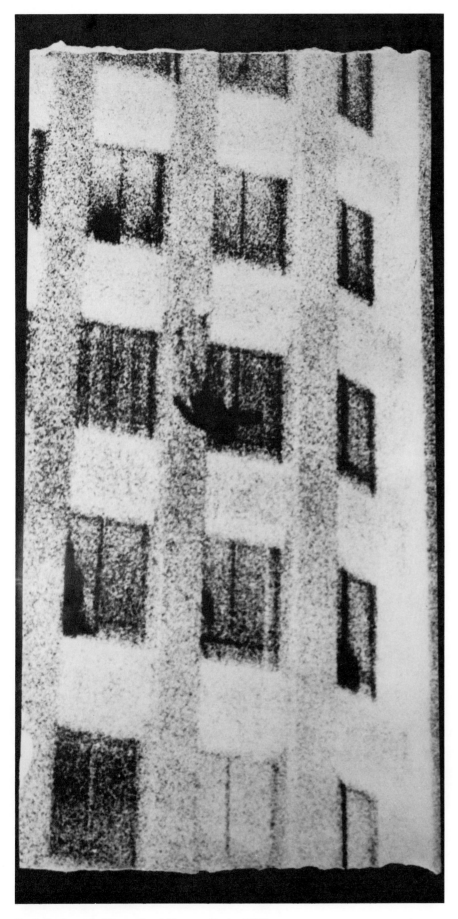

Sarah Charlesworth, *Thomas Brook Simmons, Bunker Hill Tower,*
Los Angeles, California, 1980, photograph, 79" X 42". Photo: EDO

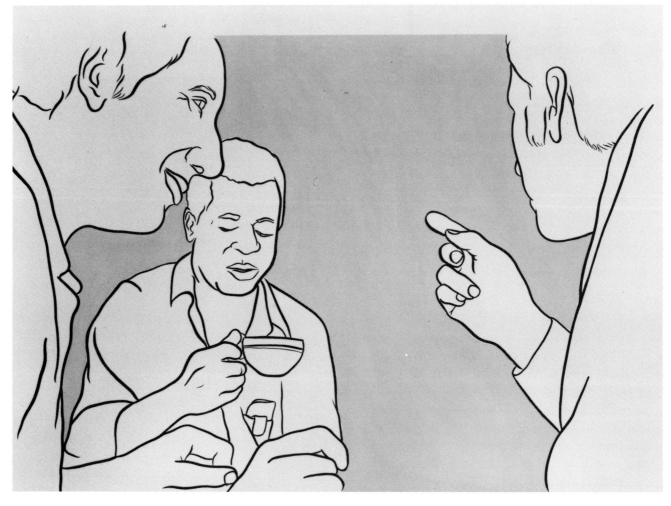

Nancy Dwyer, *Shop Talk,* 1981, poster paint on paper 37" X 48".
Photo: Kevin Noble

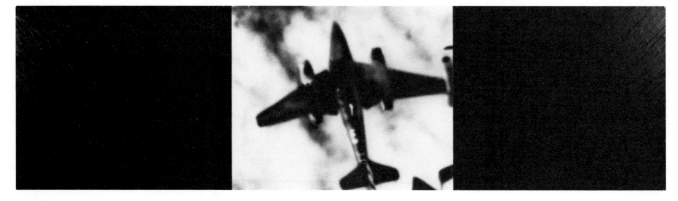

Jack Goldstein, *Untitled, 1981,* acrylic on masonite, 3 panels,
each 30" X 36"

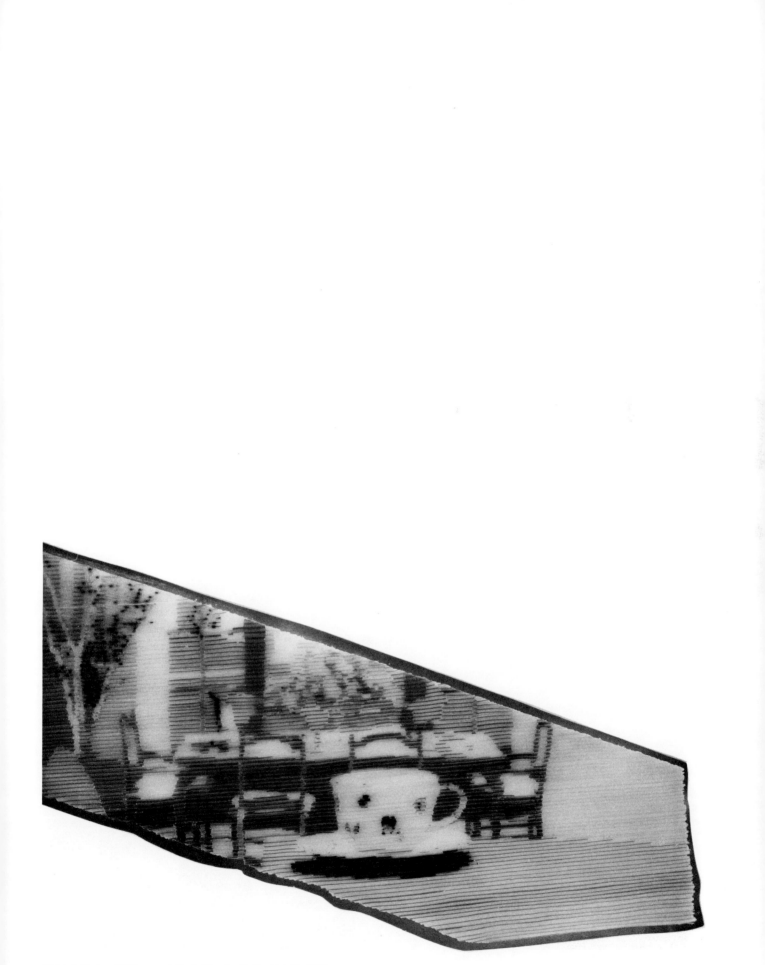

Richards Jarden, *TV Fragment: Early Morning Coffee* (detail), 1982,
laminated wax relief, 4" X 15"

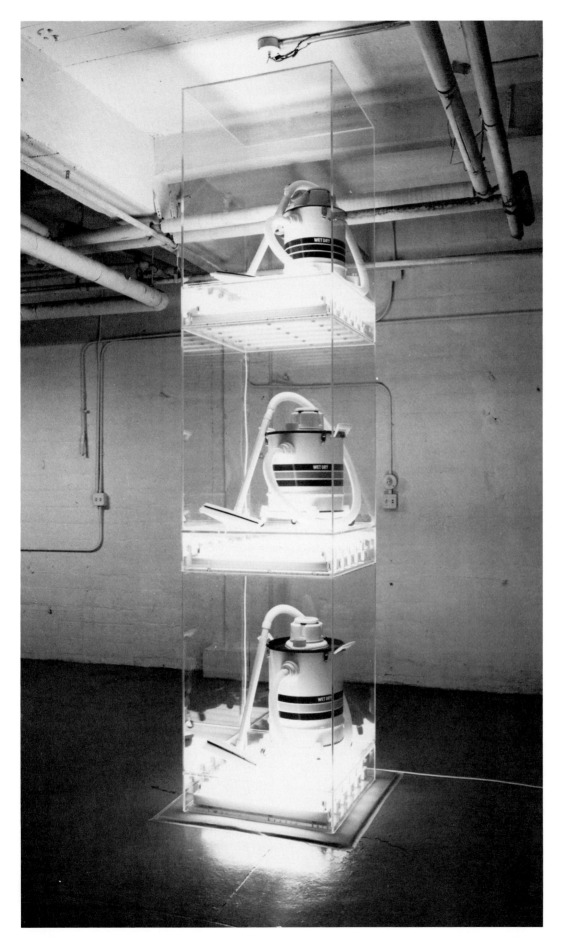

Jeff Koons, *New Sheldon Wet/Dry Tripledecker,* 1982, 124½" X 28" X 28"

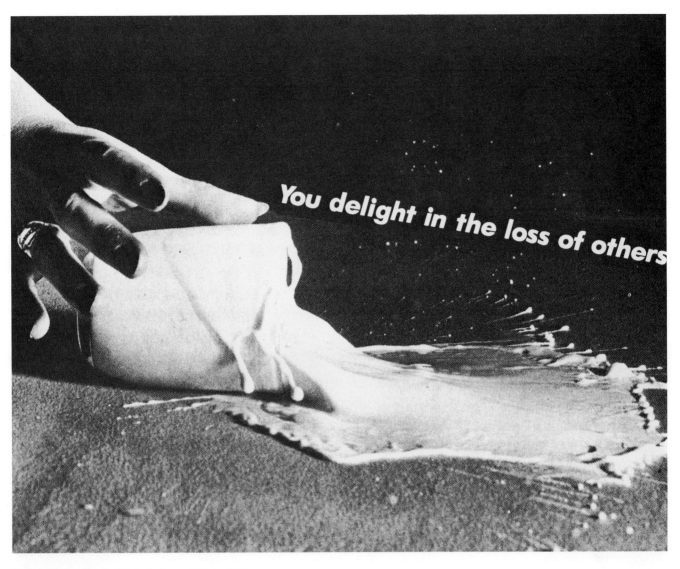

Barbara Kruger, *You Delight in the Loss of Others,* 1982,
photostat, 40" X 50"

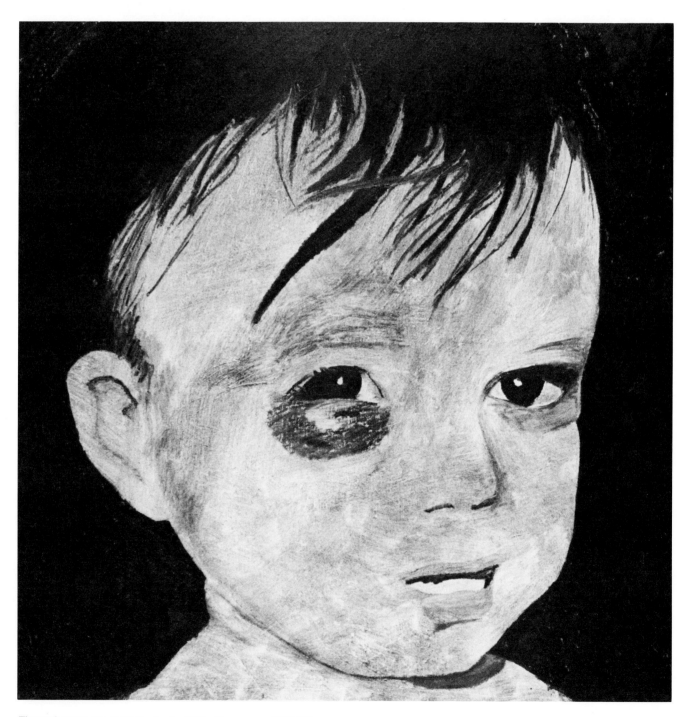

Thomas Lawson, *Don't Hit Her Again,* 1981, oil on canvas, 48" X 48"

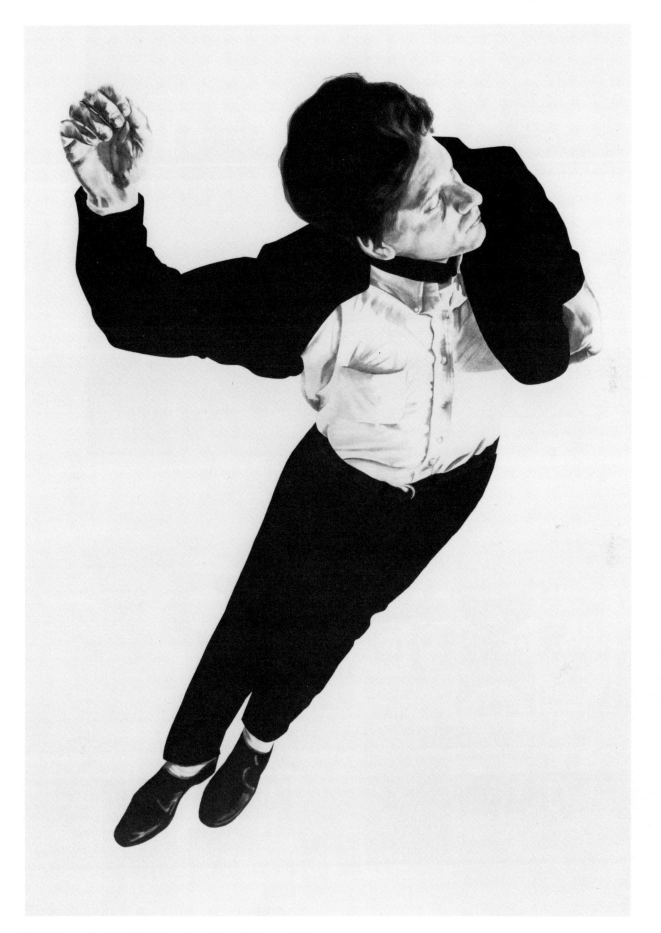

Robert Longo, *Untitled*, 1982, charcoal, graphite and silkscreen ink on
paper, 84" X 60". Photo: Pelka/Noble

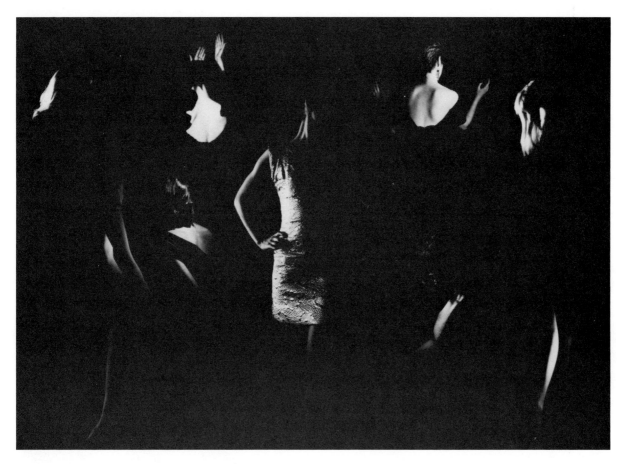

Frank Majore, *Hong Kong Gardens,* 1982, silver print, 11" X 15"

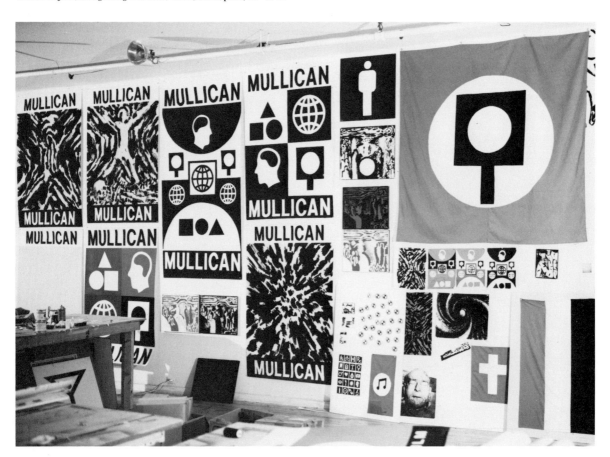

Matt Mullican, Installation: Signs, Posters, Flags, 1981. Photo: Pelka/Noble

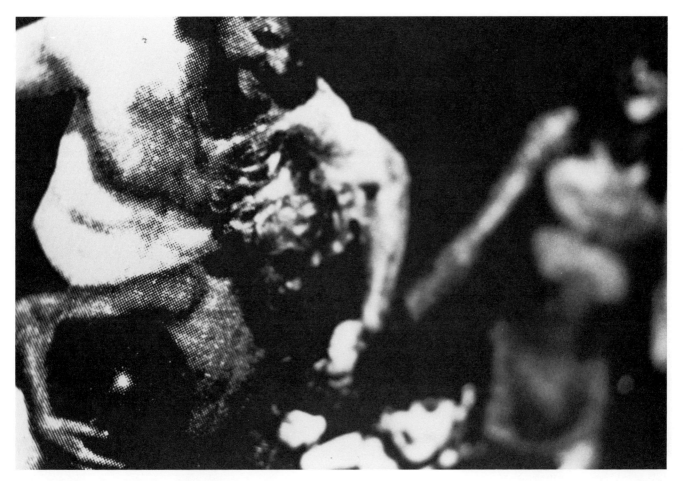

Richard Prince, *Untitled,* 1981, color photograph, 26½" X 39½"

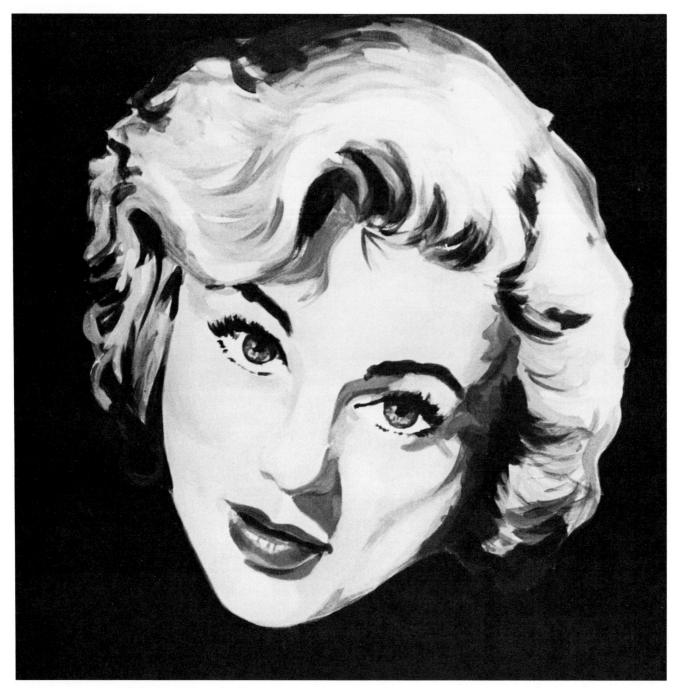

Walter Robinson, *Untitled*, 1981, acrylic on masonite, 16" X 16"

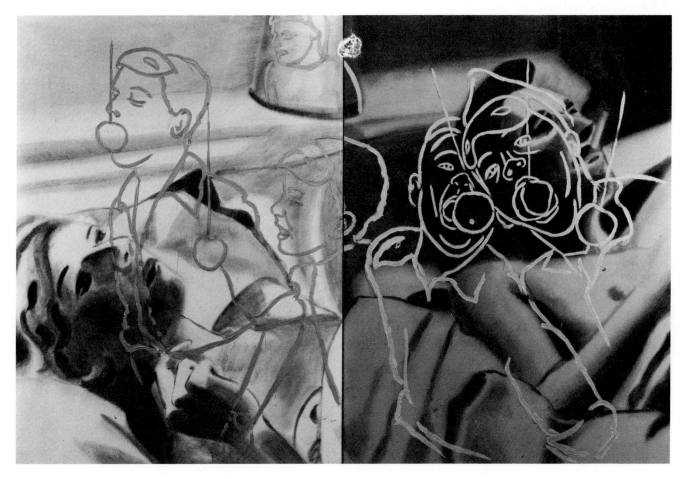

David Salle, *We'll Shake the Bag,* 1980, acrylic on canvas, 48" X 72".
Photo: Glen Steigelman, Inc.

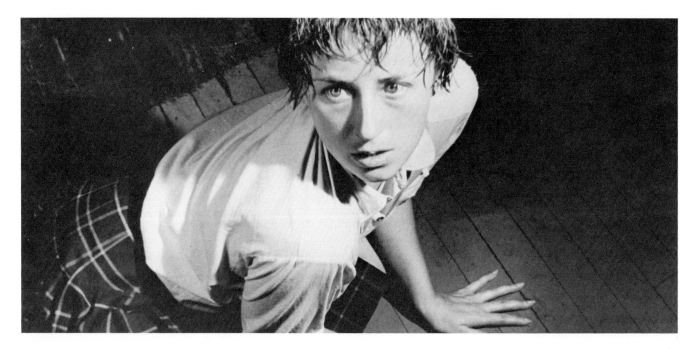

Cindy Sherman, *Untitled,* 1981, type C print photograph, 24" X 48"

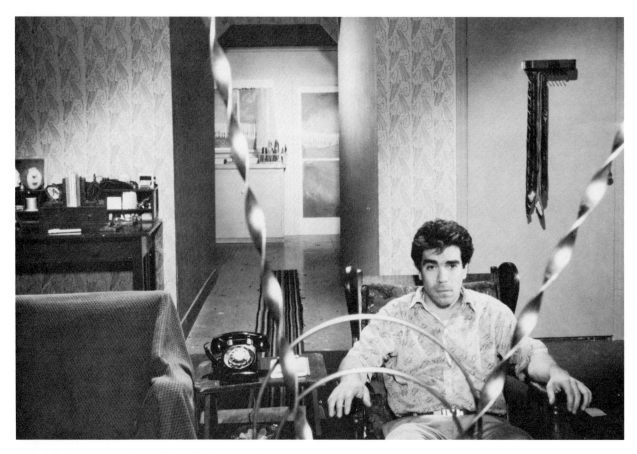

Michael Smith, *It Starts at Home,* 1982, ¾" videotape, color, stereo
sound, 25 min., still from videotape

Catalogue

1. Donald Baechler
 Don's Dilemma I, 1982
 Enamel on paper
 46 X 35 inches
 Lent by Tony Shafrazi Gallery, New York City

2. Donald Baechler
 Don's Dilemma II, 1982
 Enamel on paper
 46 X 35 inches
 Lent by Tony Shafrazi Gallery, New York City

3. Dara Birnbaum
 Technology Transformation: Wonder Woman, 1978
 ¾" videotape cassette, color, sound, NTSC, 7 minutes
 Lent by the artist

4. Dara Birnbaum
 Kiss the Girls: Make Them Cry, 1979
 ¾" videotape cassette, color, sound, NTSC, 7 minutes
 Lent by the artist

5. Dara Birnbaum
 Pop-Pop-Video: General Hospital/Olympic Women Speed Skating, 1980
 ¾" videotape cassette, color, sound, NTSC, 6 minutes
 Lent by the artist

6. Dara Birnbaum
 Pop-Pop-Video: Kojak/Wang, 1980
 ¾" videotape cassette, color, sound, NTSC, 4 minutes
 Lent by the artist

7. Dara Birnbaum
 Remy/Grand Central: Trains and Boats and Planes, 1980
 ¾" videotape cassette, color, sound, NTSC, 4 minutes
 Lent by the artist

8. Barbara Bloom
 The Diamond Lane, 1981
 35mm, color; written/directed by Barbara Bloom;
 produced by Tom Burghard—Largo Films, NL; camera:
 Theo van de Sande; music: Peter Gordon; consultant:
 Van Lagestein; starring: Susan Davis, Eric Fischl,
 Marianne de Graaf, Cees van Hoorn; laboratory:
 Cineco, NL
 Lent by the artist

9. Eric Bogosian
 Selections from *Ricky Paul Show*, November 1979
 Videotape of performance
 Lent by the artist

10. Eric Bogosian
 Selections from *Men Inside*, April 1981
 Videotape of performance
 Lent by the artist

11. Eric Bogosian
 The New World, May 1981
 Videotape of performance
 Lent by the artist

12. Eric Bogosian
 On the Air Live at Club 57, December 1981
 Videotape of performance
 Lent by the artist

13. Troy Brauntuch
 Untitled, 1981
 Photograph on paper
 97 X 165 inches
 Lent by Dupuy Warrick Reed, courtesy of Mary
 Boone Gallery, New York City

14. Troy Brauntuch
 Untitled, 1982
 Pencil on paper
 46 X 32 inches
 Lent by Mary Boone Gallery, New York City

15. Sarah Charlesworth
 Thomas Brook Simmons, Bunker Hill Tower, Los Angeles, California, 1980
 Photographic mural print
 79 X 42 inches
 Lent by Tony Shafrazi Gallery, New York City

16. Sarah Charlesworth
 Explosion, 1981
 Photographic mural print
 50 X 64 inches
 Lent by Tony Shafrazi Gallery, New York City

17. Sarah Charlesworth
 Stone Tablet, 1981
 Photographic mural print
 66 X 50 inches
 Lent by Tony Shafrazi Gallery, New York City

18. Nancy Dwyer
 Shop Talk, 1981
 Poster paint on paper
 37 X 48 inches
 Lent by the artist

19. Nancy Dwyer
 Parental Support, 1982
 Acrylic on canvas
 72 X 60 inches
 Lent by the artist

20. Jack Goldstein
Space Time Deity, 1973
16mm, color, sound
Lent by the artist, courtesy of Metro Pictures,
New York City

21. Jack Goldstein
Portrait of Pere Tanguy, 1974
16mm, color, sound
Lent by the artist, courtesy of Metro Pictures,
New York City

22. Jack Goldstein
White Dove, Shane, A Ballet Shoe, Metro-Goldwyn-Mayer, The Knife, The Chair, 1975
16mm, color, sound
Lent by the artist, courtesy of Metro Pictures,
New York City

23. Jack Goldstein
Bone China, 1976
16mm, color, sound
Lent by the artist, courtesy of Metro Pictures,
New York City

24. Jack Goldstein
The Jump, 1978
16mm, color, sound
Lent by the artist, courtesy of Metro Pictures,
New York City

25. Jack Goldstein
Untitled, 1981
Acrylic on canvas
96 X 72 inches
Lent by Metro Pictures, New York City

26. Jack Goldstein
Untitled, 1981
Acrylic on masonite, 3 panels
30 X 108 inches (overall)
Lent by Metro Pictures, New York City

27. Richards Jarden
TV Fragment: Early Morning Coffee, 1982
Laminated wax relief
4 X 15 inches
Lent by the artist

28. Richards Jarden
TV Fragment: Flower Pot, 1982
Laminated wax relief
4¼ X 4¼ inches
Lent by the artist

29. Richards Jarden
TV Fragment: Lamp & Phone, 1982
Laminated wax relief
5⅛ X 2½ inches
Lent by the artist

30. Richards Jarden
TV Fragment: Living Room, 1982
Laminated wax relief
2 X 6¼ inches
Lent by the artist

31. Jeff Koons
New Sheldon Wet/Dry Tripledecker, 1982
New Sheldon Wet/Dry vacuums, acrylic,
fluorescent lights
124½ X 28 X 28 inches
Lent by the artist

32. Barbara Kruger
You Delight in the Loss of Others, 1982
Photostat
40 X 50 inches
Lent by Annina Nosei Gallery, New York City

33. Barbara Kruger
Your Every Wish is Our Command, 1982
Photostat
60 X 40 inches
Lent by Annina Nosei Gallery, New York City

34. Thomas Lawson
Don't Hit Her Again, 1981
Oil on canvas
48 X 48 inches
Lent by Metro Pictures, New York City

35. Thomas Lawson
Happy to Be Alive, 1982
Oil on canvas
48 X 96 inches
Lent by Metro Pictures, New York City

36. Robert Longo
The Pilots, 1979
Wood panel and lacquer paint
68 X 49 X 12 inches
Lent by Alexander Madero, New York City

37. Robert Longo
Untitled, 1982
Charcoal, graphite, silkscreen ink on paper
84 X 60 inches
Lent by Metro Pictures, New York City

38. Robert Longo
Untitled, 1982
Charcoal, graphite, silkscreen ink on paper
84 X 60 inches
Lent by Metro Pictures, New York City

39. Frank Majore
A Rose, 1981
Cibachrome
14 X 11 inches
Lent by the artist

40. Frank Majore
Blue Trimline, 1981
Cibachrome
13½ X 10 inches
Lent by the artist

41. Frank Majore
A Rose, 1982
Cibachrome
14 X 11 inches
Lent by the artist

42. Frank Majore
Hong Kong Gardens, 1982
Silver Print
11 X 15 inches
Lent by the artist

43. Matt Mullican
Untitled (Subjective World, Sign World, Framed World, Real World, Elemental World), 1981
Nylon appliqué on nylon
119 X 83 inches
Lent by Mary Boone Gallery, New York City

44. Richard Prince
Untitled, 1981
Color photograph
26½ X 39½ inches
Lent by Metro Pictures, New York City

45. Richard Prince
Untitled, 1981
Color photograph
26½ X 39½ inches
Lent by Metro Pictures, New York City

46. Walter Robinson
Untitled, 1981
Acrylic on canvas
16 X 16 inches
Lent by Metro Pictures, New York City

47. Walter Robinson
Untitled, 1981
Acrylic on canvas
16 X 16 inches
Lent by Metro Pictures, New York City

48. Walter Robinson
Untitled, 1981
Acrylic on canvas
16 X 16 inches
Lent by Metro Pictures, New York City

49. Walter Robinson
Untitled, 1981
Acrylic on canvas
16 X 16 inches
Lent by Metro Pictures, New York City

50. David Salle
We'll Shake the Bag, 1980
Acrylic on canvas
48 X 72 inches
Private Collection, courtesy of Mary Boone/
Leo Castelli Galleries, New York City

51. David Salle
Sliver Man, 1982
Acrylic, oil on canvas
72 X 134 inches
Lent by Mary Boone/Leo Castelli Galleries,
New York City

52. Cindy Sherman
Untitled, 1981
Type C print photograph
24 X 48 inches
Lent by Gretchen Brown, Chicago

53. Cindy Sherman
Untitled, 1981
Type C print photograph
24 X 48 inches
Lent by David Lawrence, Chicago

54. Cindy Sherman
Untitled, 1981
24 X 48 inches
Lent by the artist, courtesy of Young Hoffman Gallery,
Chicago

55. Cindy Sherman,
Untitled, 1981
Type C print photograph
24 X 48 inches
Lent by the artist, courtesy of Young Hoffman Gallery,
Chicago

56. Michael Smith
It Starts at Home, 1982
¾" videotape cassette, color, stereo sound,
25 minutes
Lent by the artist

In the catalogue height precedes width.

The Renaissance Society at The University of Chicago